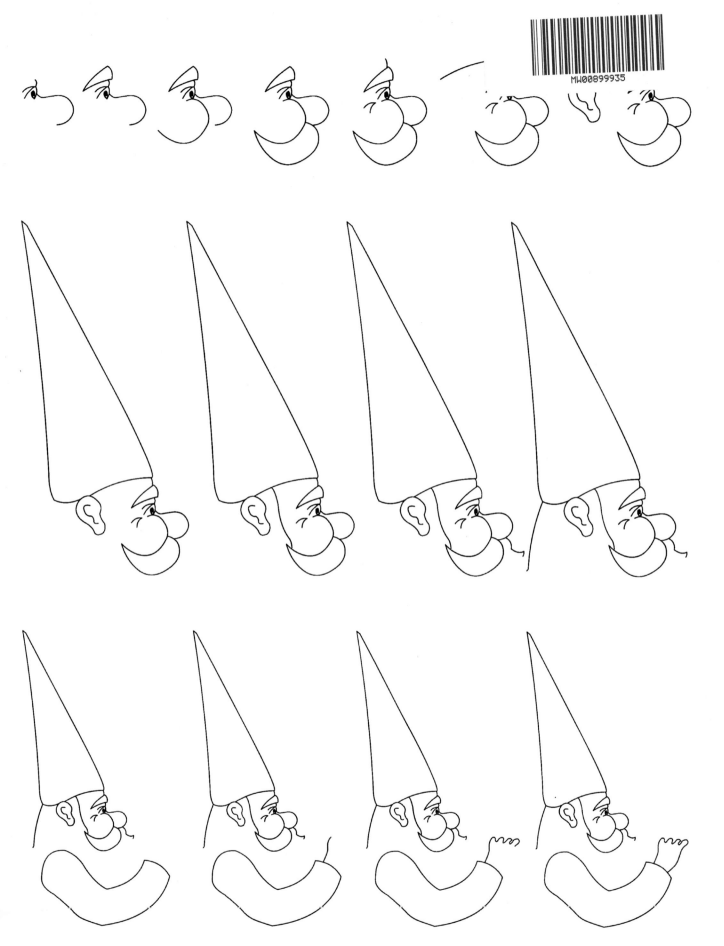

© Amit Offir

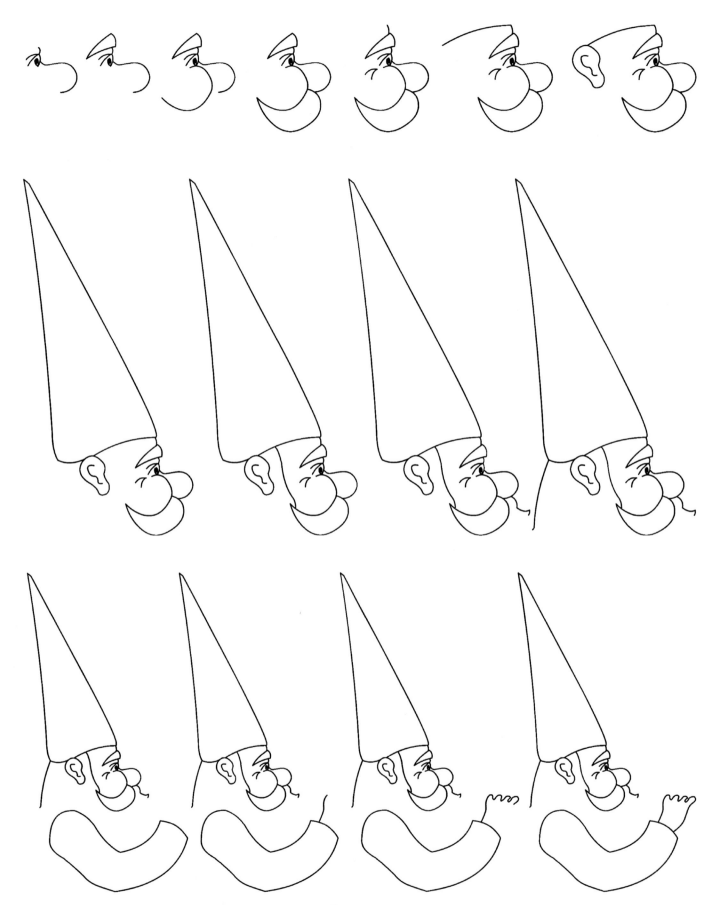

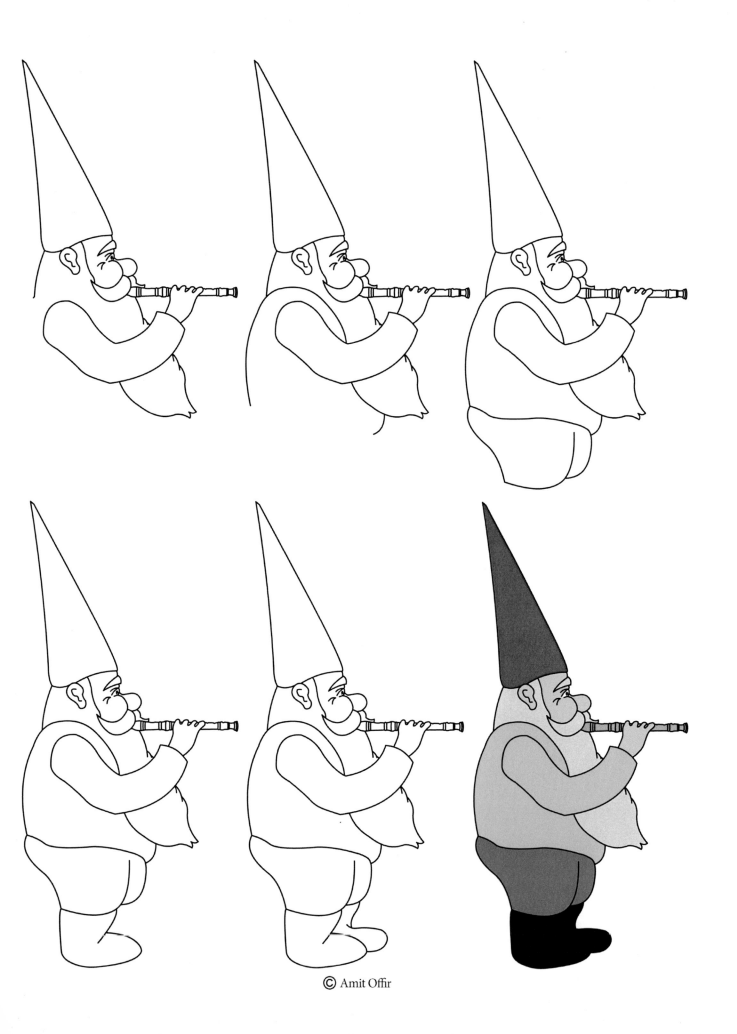

© Amit Offir

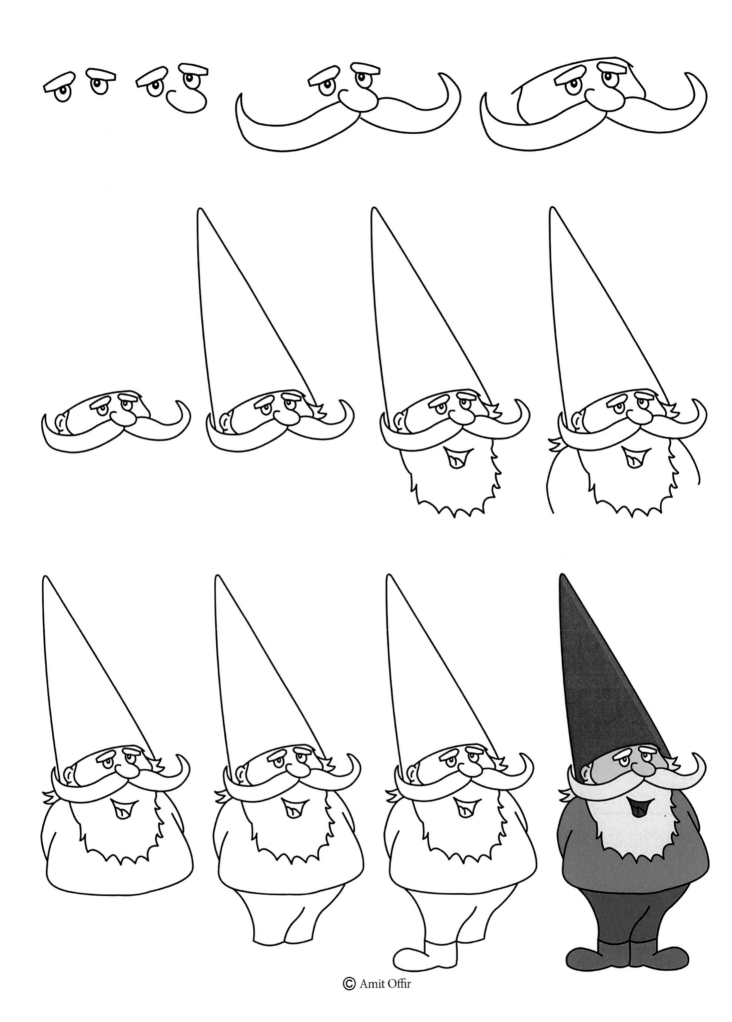

© Amit Offir

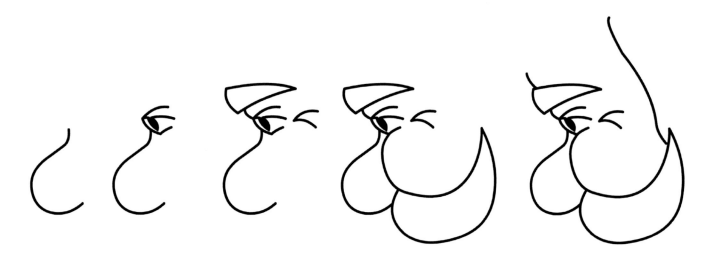

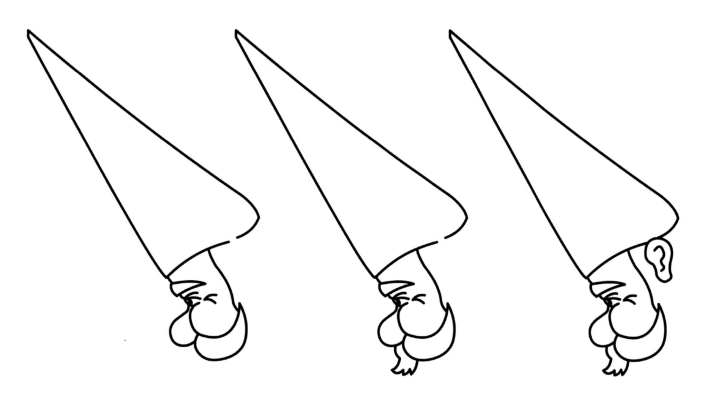

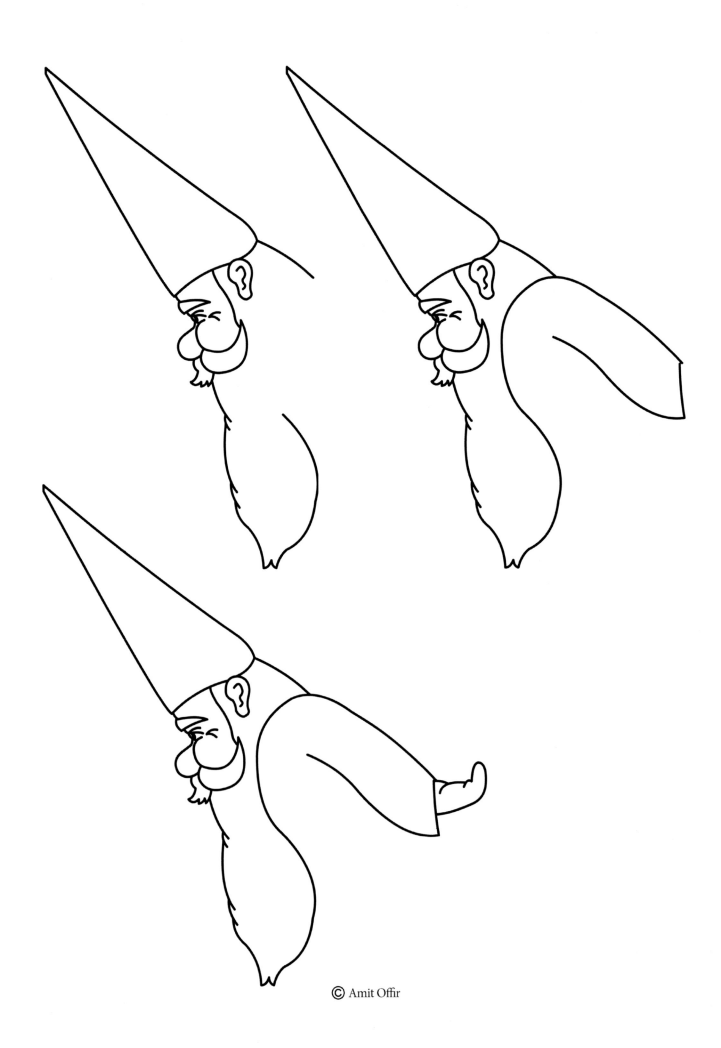

© Amit Offir

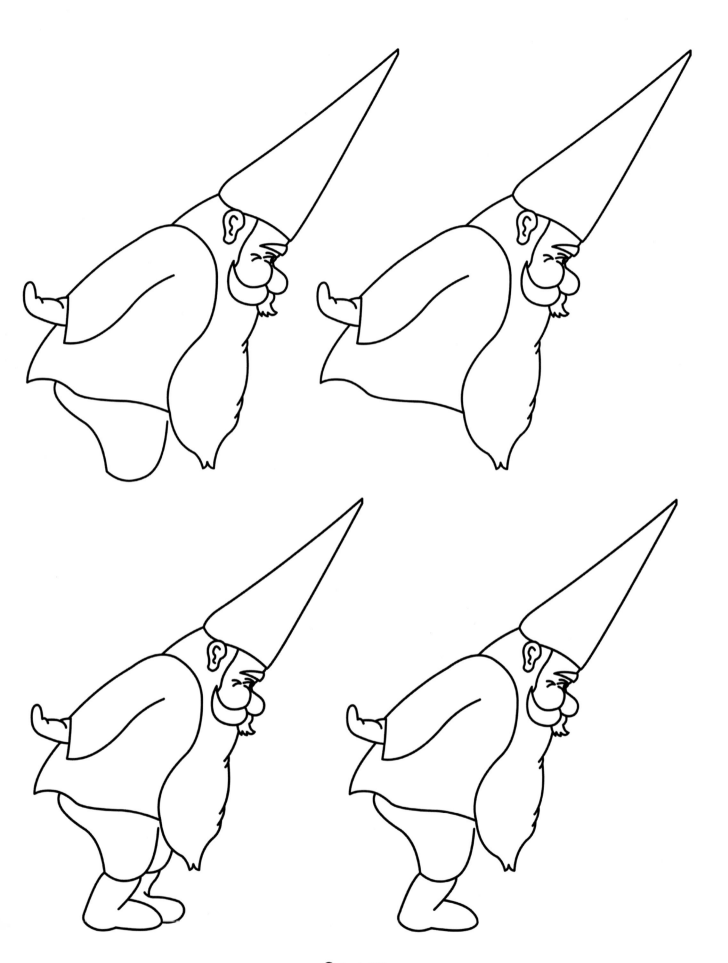

© Amit Offir

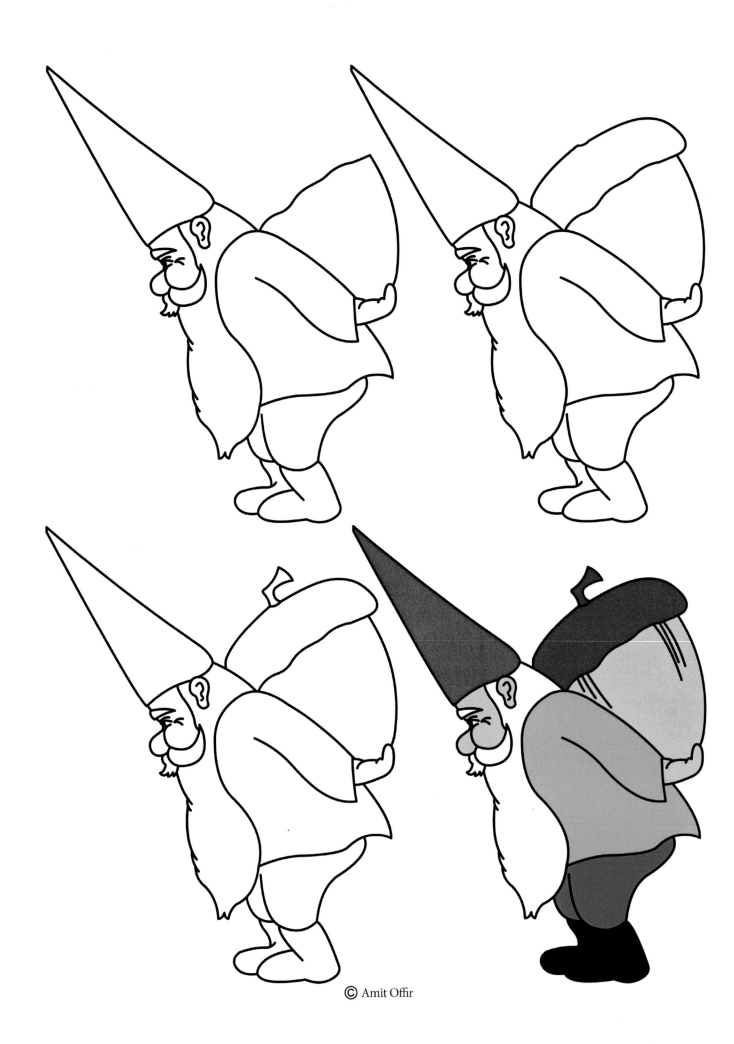

© Amit Offir

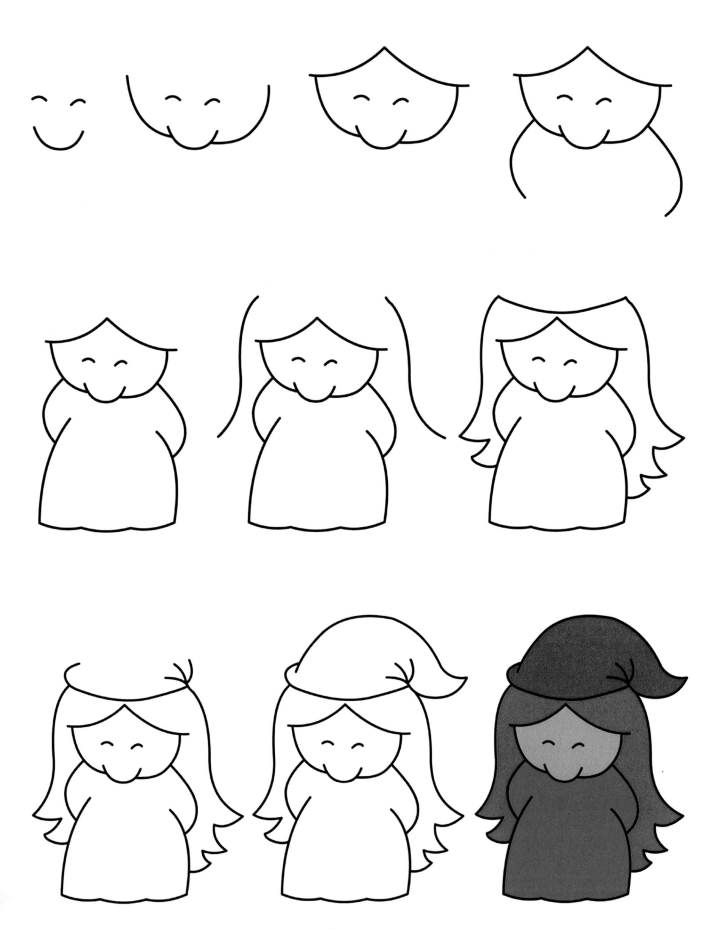

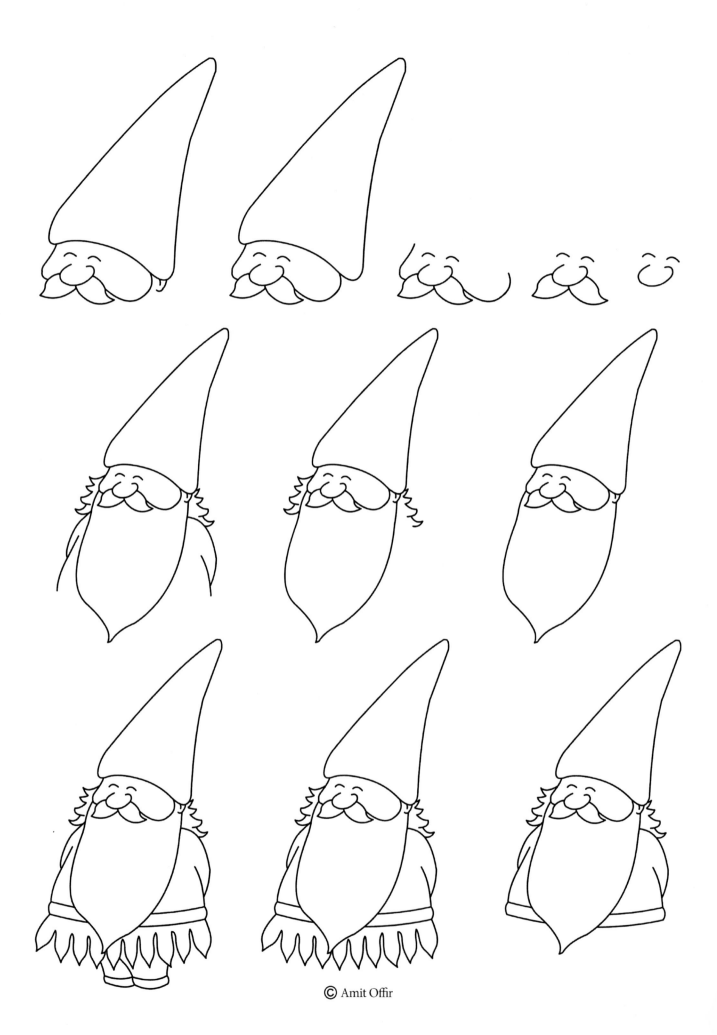

© Amit Offir

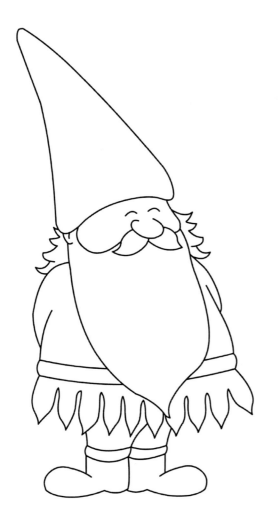 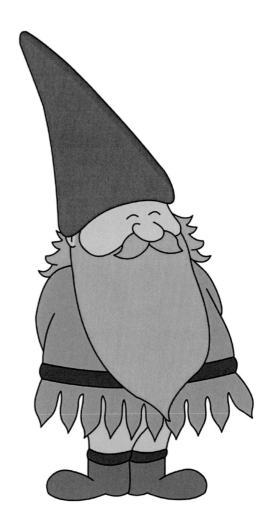

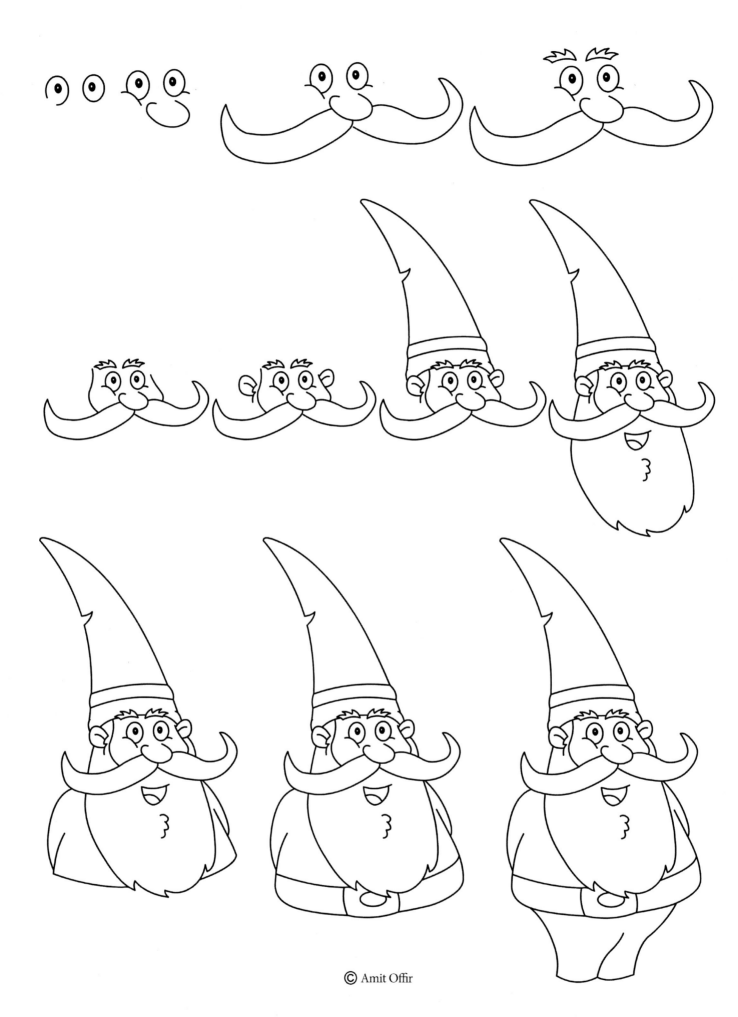

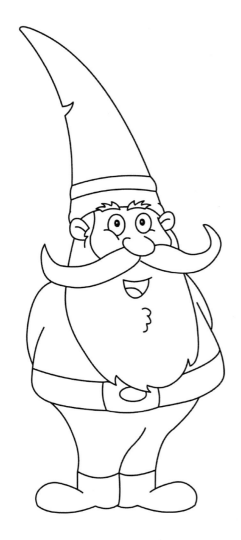 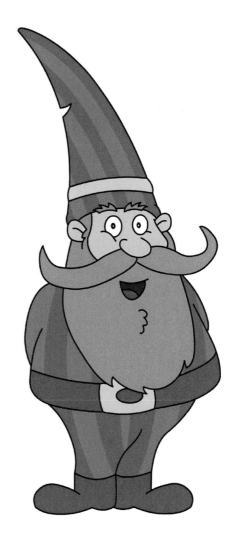

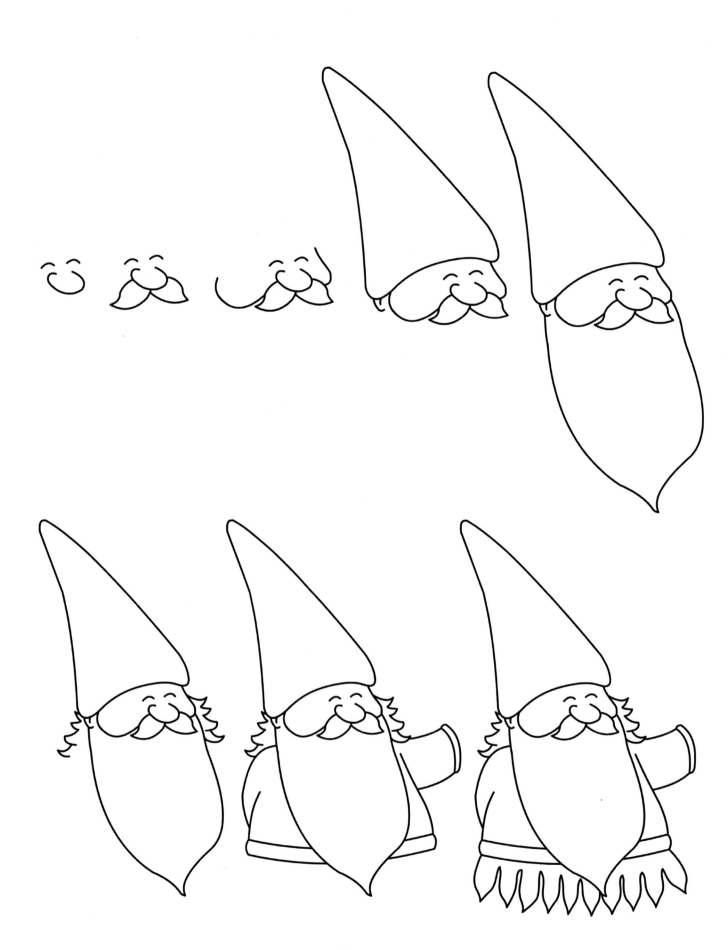

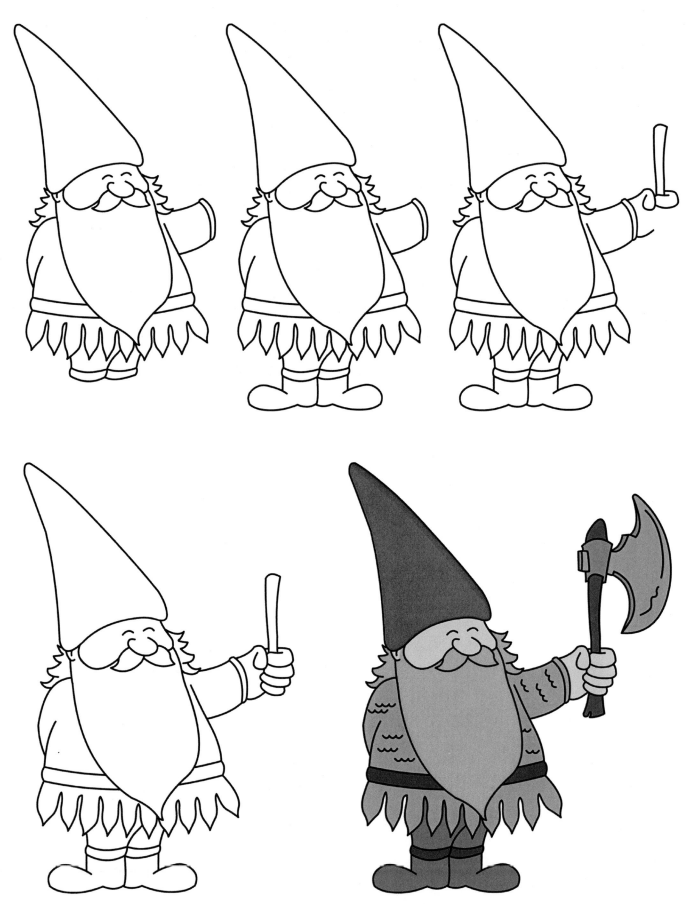

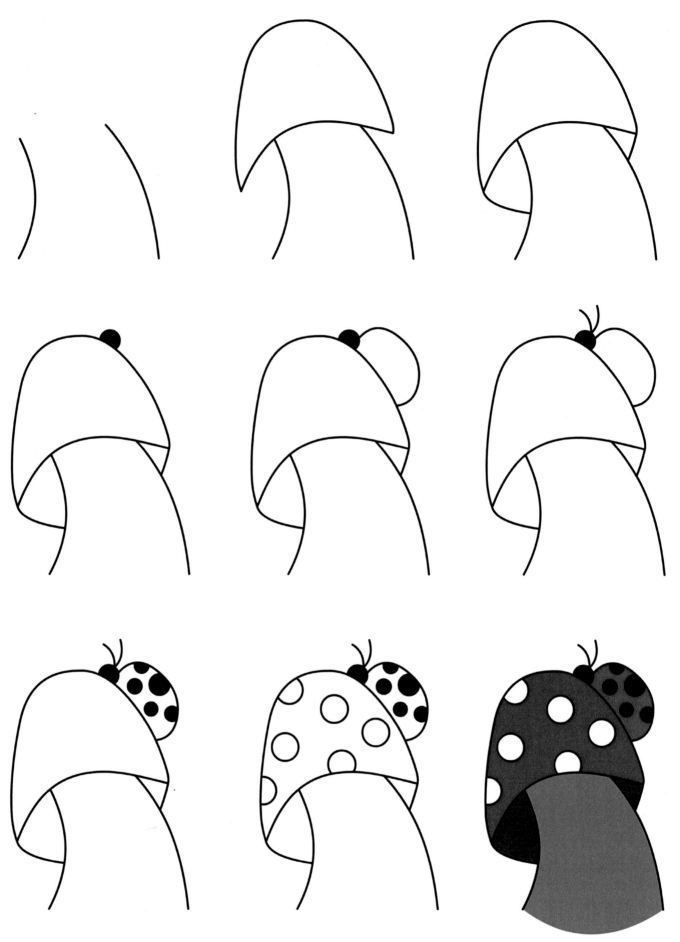

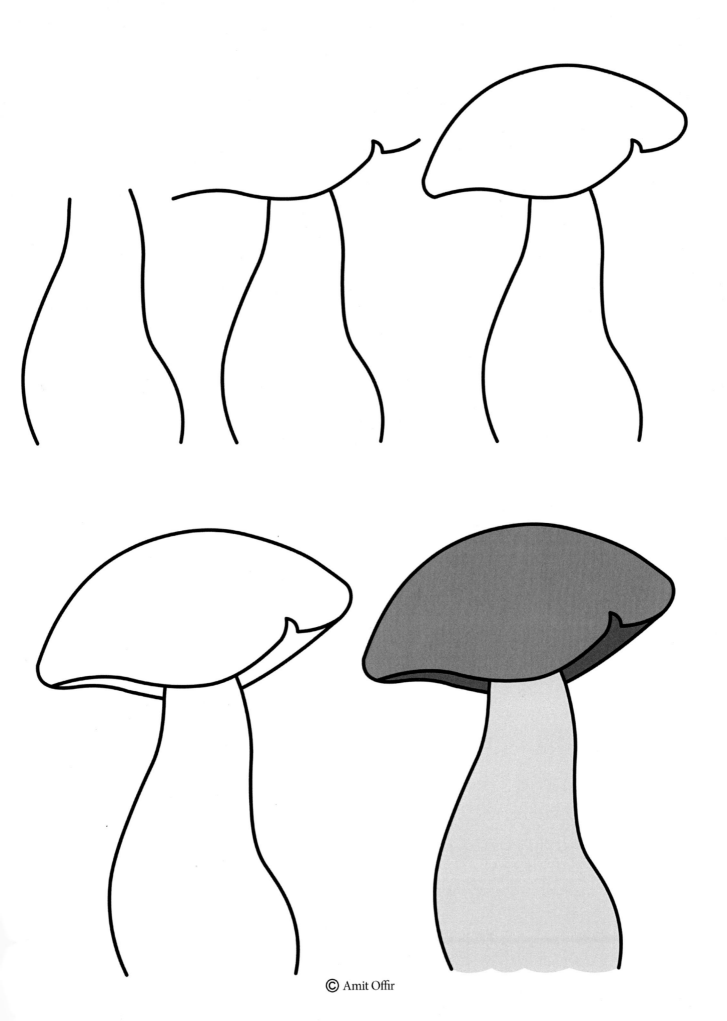

© Amit Offir

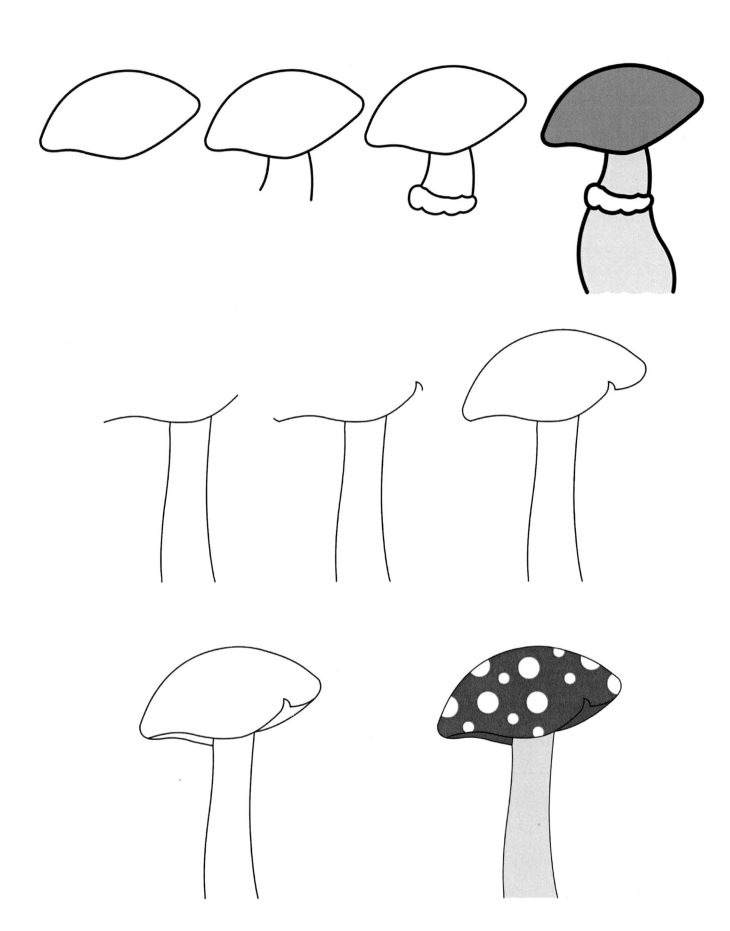

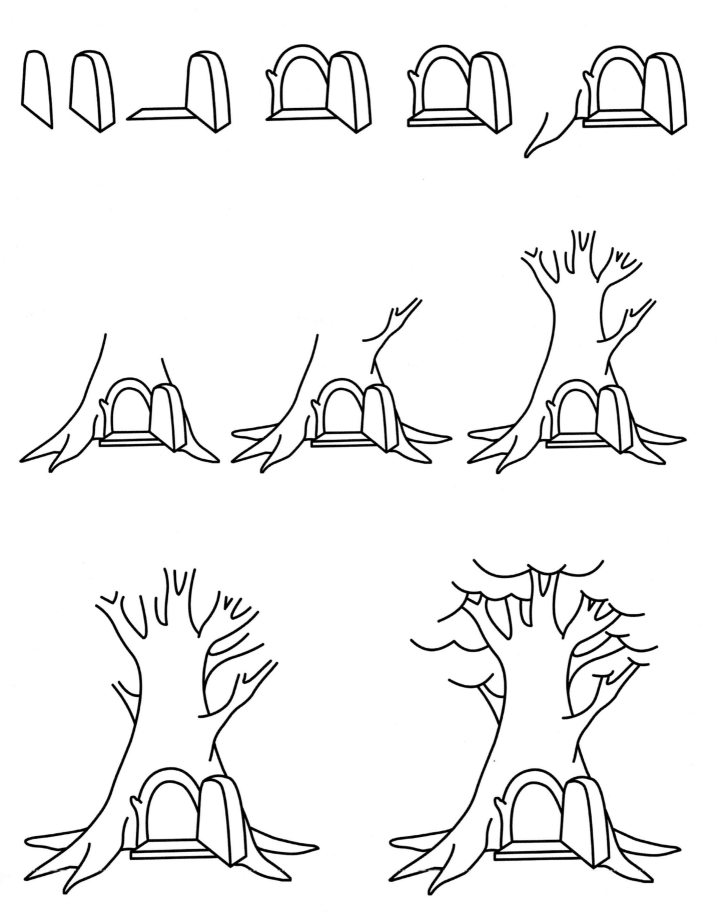

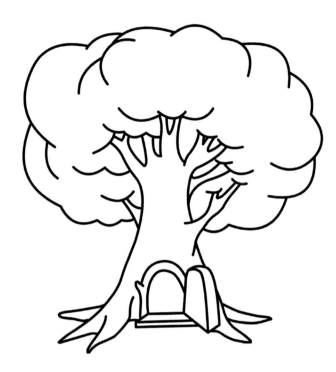 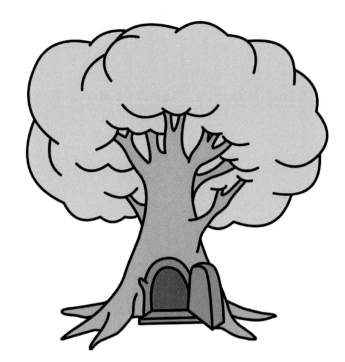

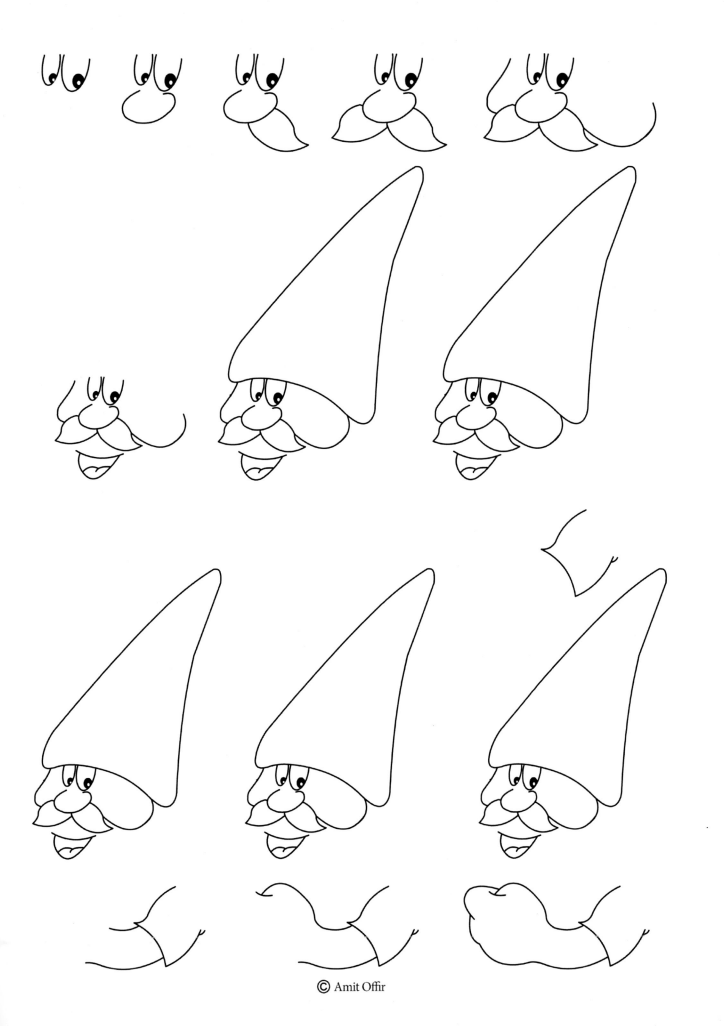

© Amit Offir

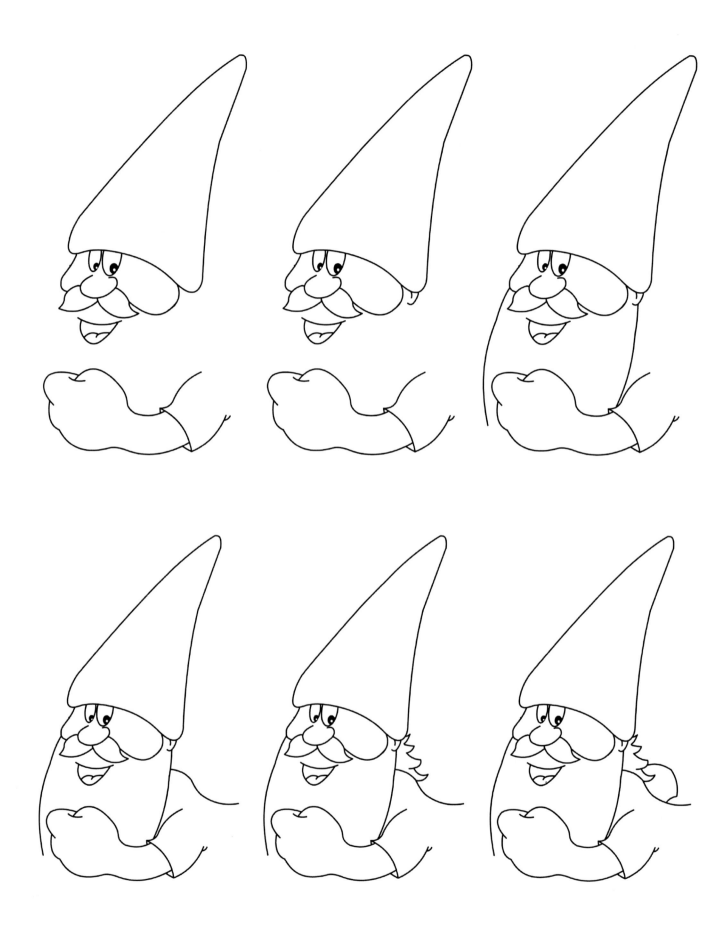

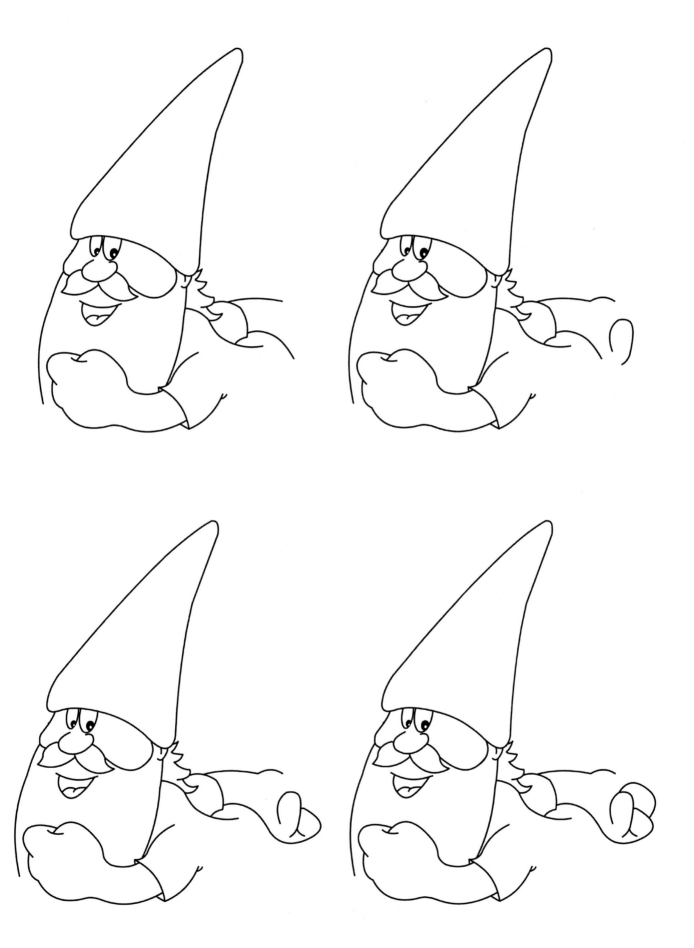

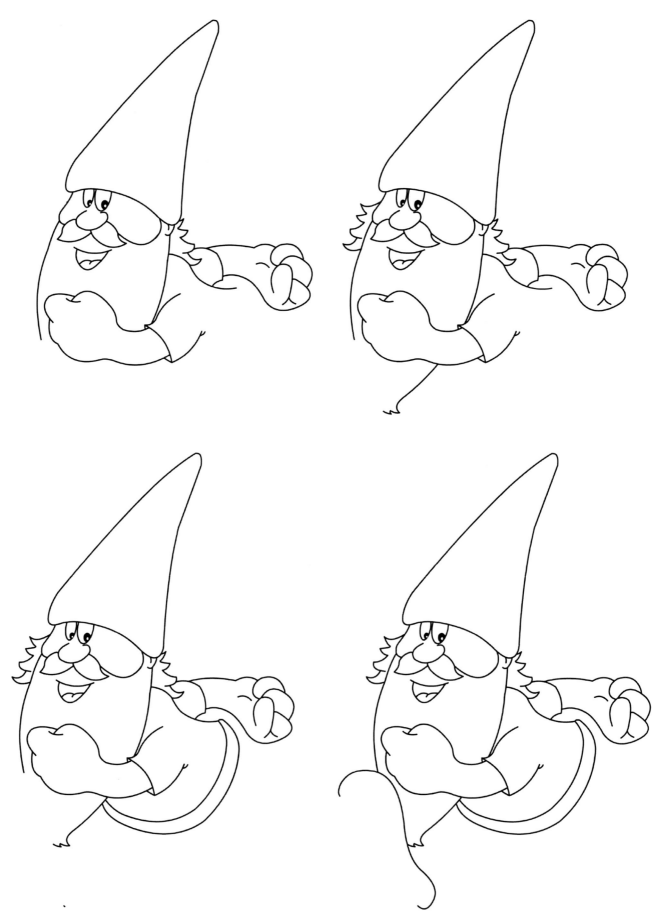

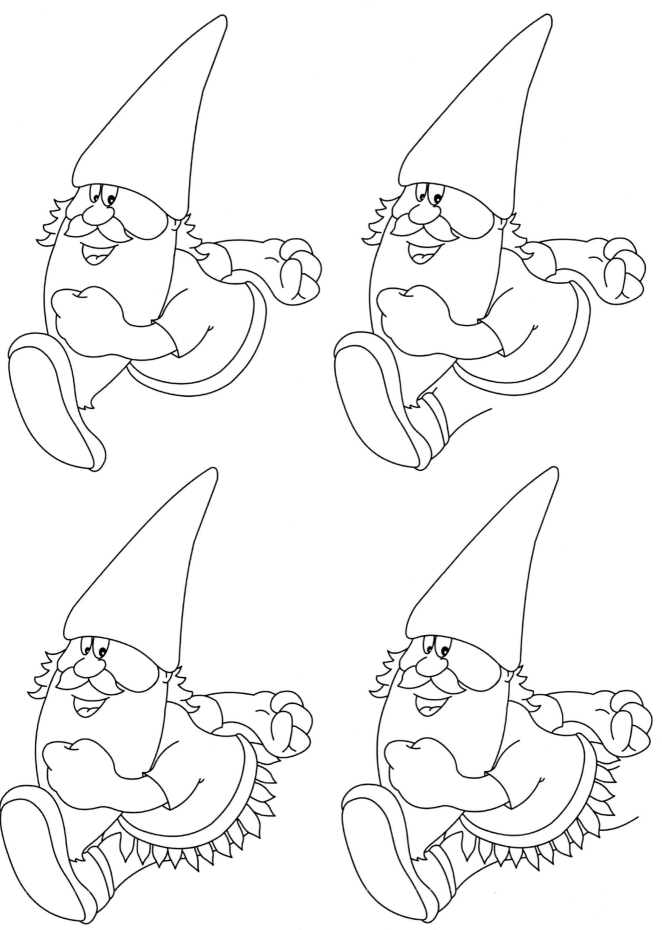

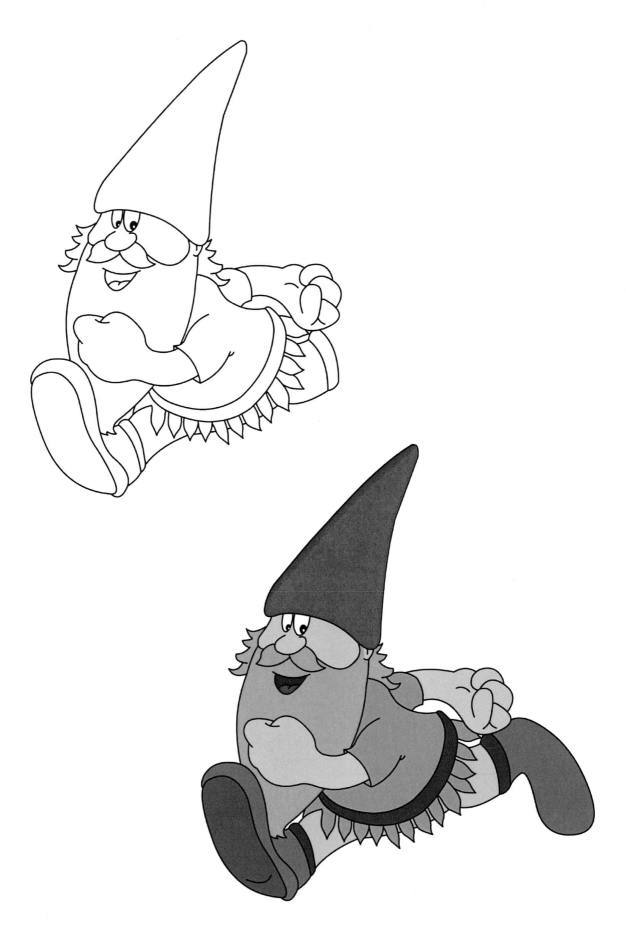

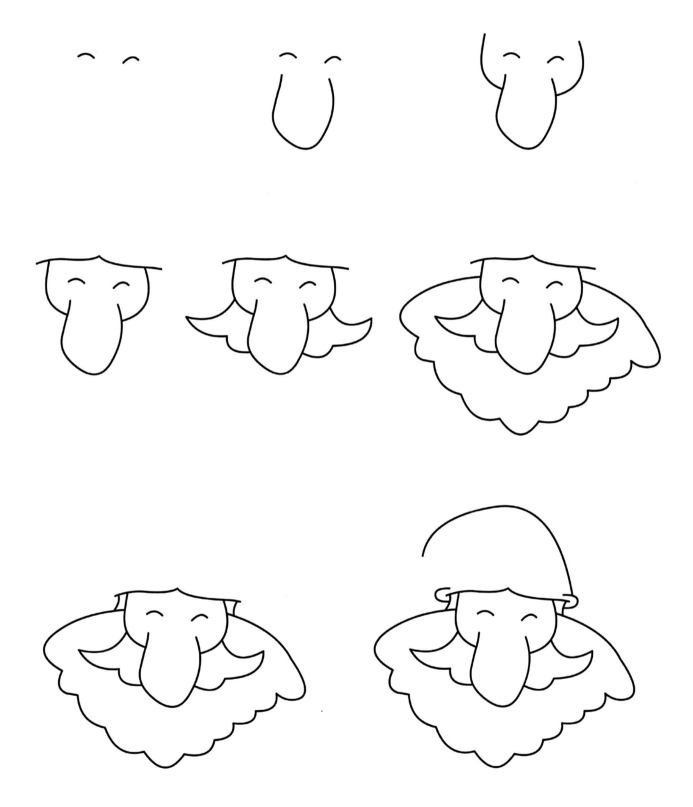

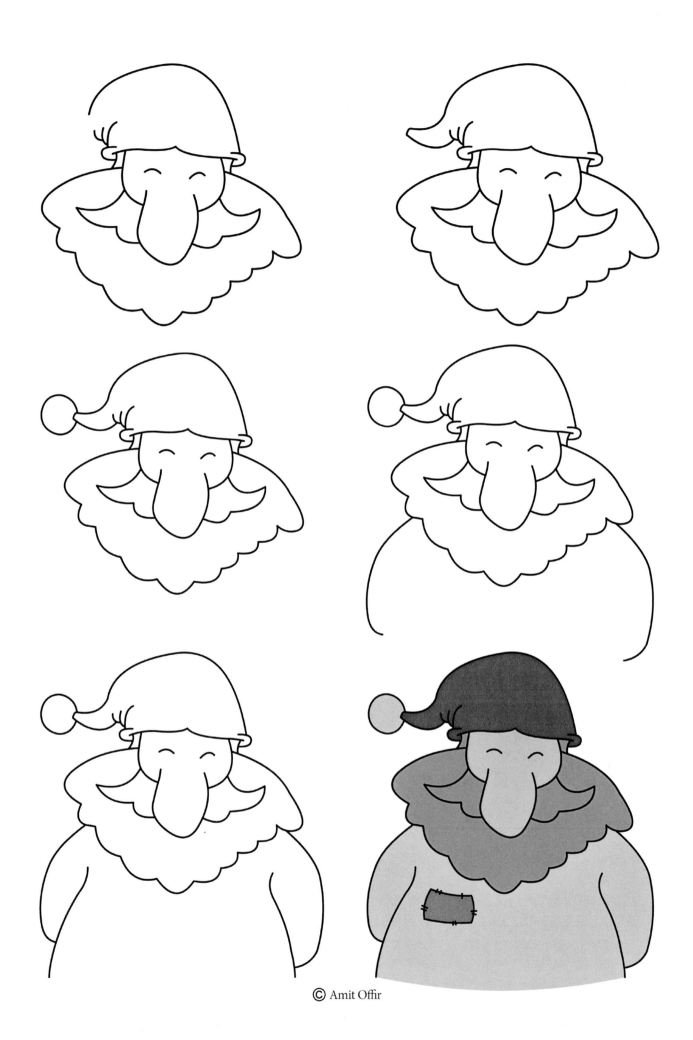

© Amit Offir

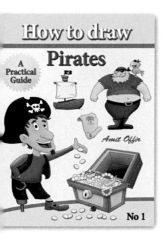

How to draw Pirates — A Practical Guide — Amit Offir — No 1

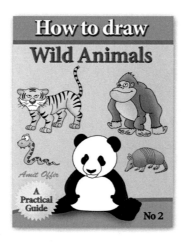

How to draw Wild Animals — Amit Offir — A Practical Guide — No 2

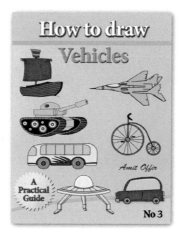

How to draw Vehicles — A Practical Guide — Amit Offir — No 3

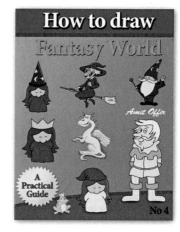

How to draw Fantasy World — Amit Offir — A Practical Guide — No 4

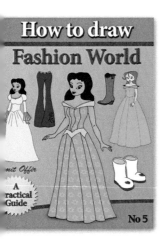

How to draw Fashion World — Amit Offir — A Practical Guide — No 5

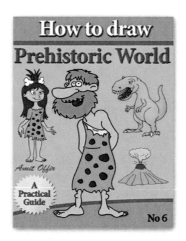

How to draw Prehistoric World — Amit Offir — A Practical Guide — No 6

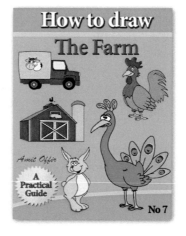

How to draw The Farm — Amit Offir — A Practical Guide — No 7

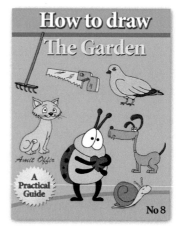

How to draw The Garden — Amit Offir — A Practical Guide — No 8

How to draw the beetle that wants to be and friends — Amit Offir — A Practical Guide — No 9

How to draw Birds — Amit Offir — A Practical Guide — No 10

How to draw Sea World — Amit Offir — A Practical Guide — No 11

How to draw Noah's Ark — Amit Offir — A Practical Guide — No 12

How to draw Food — Amit Offir — A Practical Guide — No 13 part 1

How to draw Plants — Amit Offir — A Practical Guide — No 14

How to draw Weapons — Amit Offir — A Practical Guide — No 15

How to draw Treasure Island — Amit Offir — A Practical Guide — No 16

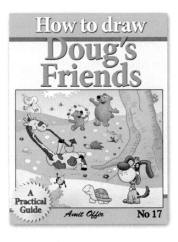

How to draw
Doug's Friends
A Practical Guide
Amit Offir
No 17

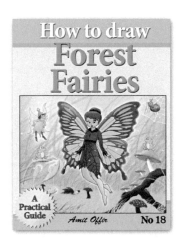

How to draw
Forest Fairies
A Practical Guide
Amit Offir
No 18

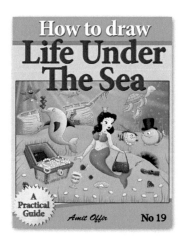

How to draw
Life Under The Sea
A Practical Guide
Amit Offir
No 19

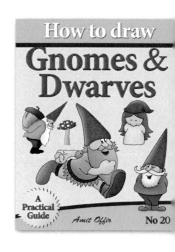

How to draw
Gnomes & Dwarves
A Practical Guide
Amit Offir
No 20

How to draw
Fruit
Amit Offir
A Practical Guide
No 21

How to draw
Vegetables
Amit Offir
A Practical Guide
No 22

How to draw
Stuff In The House
A Practical Guide
Amit Offir
No 23

How to draw
Moses in Egypt
A Practical Guide
Amit Offir
No 24

How to draw
Berry in the Forest
A Practical Guide
Amit Offir
No 25

How to draw
Dinosaurs
A Practical Guide
Amit Offir
No 26

How to draw
Shula The Cow
A Practical Guide
Amit Offir
No 27

How to draw
Musical Instruments
No 28
A Practical Guide

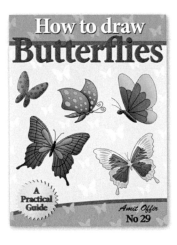

How to draw
Butterflies
A Practical Guide
Amit Offir
No 29

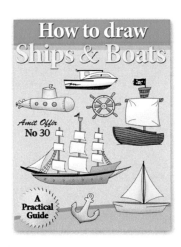

How to draw
Ships & Boats
Amit Offir
No 30
A Practical Guide

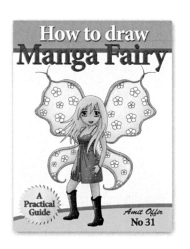

How to draw
Manga Fairy
A Practical Guide
Amit Offir
No 31

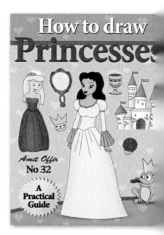

How to draw
Princesses
Amit Offir
No 32
A Practical Guide

How to draw
Mali The Sheep

A Practical Guide

Amit Offir No 33

How to draw
Mali the Sheep in Space

A Practical Guide

Amit Offir No 34

How to draw
Space

A Practical Guide

Amit Offir No 35

How to draw
Sports World

Amit Offir

No 36 A Practical Guide

36 BOOKS

over 1110 pages!

How to draw 1-12
Collection

How to draw 25-36
Collection

How to draw 13-24
Collection

How to Draw
Christmas

Amit Offir

No 37

Made in the USA
Middletown, DE
09 December 2016